M. Chagall

THE LIFE AND WORKS OF

CHAGALL

Nathaniel Harris

A Compilation of Works from the
BRIDGEMAN ART LIBRARY

‖ •PARRAGON• ‖

Chagall

This edition first published in Great Britain in 1994
by Parragon Book Service Limited

© 1994 Parragon Book Service Limited

ISBN 1 85813 626 1

Printed in Italy

Editor: Alexa Stace
Designer: Robert Mathias
Picture Research: Kathy Lockley

Marc Chagall 1887 - 1985

Marc Chagall created his own colourful world of myth and magic, filled with strange creatures and miraculous events. Yet his art was essentially grounded in real memories and experiences, which he transmuted in the crucible of his imagination. A man almost entirely absorbed in his work and family life, he was fated to confront the most varied cultures, to live through wars and revolutions, and to endure flight and exile. Consequently, in any account of Chagall, art and autobiography are intimately, if obliquely, linked.

Chagall was born on 7 July 1887 into a poor Jewish family at Pestkovatik, a village in the western province of Tsarist Russia which is now independent Belarus. A few years later the Shagals moved to the nearby town of Vitebsk, which became one of the principal landmarks in their son's paintings. The oldest of nine children, Moshe Shagal – a name later turned into French as Marc Chagall – grew up in the enclosed atmosphere of an East European Jewish community that was still subject to persecution and ferocious outbursts of official and unofficial violence.

Inevitably, Chagall's Jewishness became one of the main threads of his life and art. He had to overcome family opposition to his chosen career, because it violated the biblical injunction against image-making; and in order to study in the capital, St Petersburg, he had to get round the

Tsarist regulations which confined Jews to the Pale of Settlement. Despite his air of unworldliness, Chagall succeeded in doing both.

After several years in St Petersburg (1906-10), he was beginning to make a reputation when a generous patron, Max Vinaver, provided the funds for him to settle in Paris, at that time the undisputed art capital of the western world. With Picasso, Braque and other now-legendary figures to the fore, (Cubism and its offshoots were revolutionizing the visual arts), Chagall exploited modernist techniques during his Paris years and for some time afterwards although he never abandoned the personal idiom he had already forged.

Paris became Chagall's 'second Vitebsk', and he almost certainly intended to settle there permanently. But in 1914, while he was on a visit to Russia, World War I broke out and he was unable to leave. In 1915 he married Bella Rosenfeld, his fiancée since 1909, celebrating their love in a remarkable series of works that he continued to paint even after her death 30 years later. Meanwhile he survived the war, working in the Office of War Economy, and even emerged after the October Revolution of 1917 as Commissar of Art for Vitebsk.

Chagall's commissarship soon ended in a confusion of disagreements with his fellow-artists, after which he worked as a theatre designer in Moscow and taught for a time at colonies set up for war orphans. Finally, in 1922, as the atmosphere in the Soviet Union became increasingly unfriendly to his non-political art, Chagall, Bella and their daughter Ida emigrated. His brief return visit had lasted for eight years.

In 1923 Chagall was commissioned by the famous French dealer Ambroise Vollard to illustrate a classic Russian novel, Gogol's *Dead Souls*. The Chagalls settled in France, and

Marc made a new reputation as an illustrator in gouache and etching while continuing his career as a painter. The years that followed were happy and prosperous ones, filled with work and travel, but the 1930s were increasingly shadowed by the rise of fascism, reflected in sombre works such as Chagall's *White Crucifixion* (page 52).

In 1937 Chagall became a naturalized French citizen – a privilege soon revoked when World War II broke out and France, defeated by the German Blitzkrieg, was divided between Nazi and collaborationist authorities. Chagall was slow to realize the danger of his position as a Jew and as an artist condemned by the Nazis as 'degenerate'. He was actually arrested in April 1941, but was released thanks to American intervention and hastily went into exile for a second time.

He spent the war years in the United States, afflicted not only by the war news but by Bella's sudden death in 1944. A few years later he formed a new relationship with an Englishwoman, Virginia Haggard, which lasted until 1952. Meanwhile he returned to France in 1948, settling for good in the south. Though he travelled widely, Chagall's days of flight and exile were over, while his marriage in 1952 to Valentine Brodsky brought him the stability he needed.

The rest of Chagall's long life was devoted to superabundant creativity. Prolific almost to the end, he died at the age of 97 on 29 March 1985.

▷ **Young Girl on a Sofa** 1907

Oil on canvas

ALSO KNOWN AS *Mariaska,* a pet name for Chagall's sister Marussia, who was about six years old when she sat for this portrait. By 1907 Chagall had managed to reach the Russian capital, St Petersburg, and was studying at the Imperial School of Fine Art, so the canvas must have been painted on one of his return visits to his family at Vitebsk. Its style is highly decorative, with the floral-patterned sofa and red background playing at least as important a role as its nominal subject. By the early years of the 20th century such a treatment was no longer new and shocking, although a meticulously 'photographic' naturalism continued to be preferred by the art establishment and the general public. Here, although the little girl's features and limbs are simplified, her solemn presence does add to the work's appeal. Her oversized hat – perhaps Chagall's own – has presumably been included as a touch of affectionate brotherly humour.

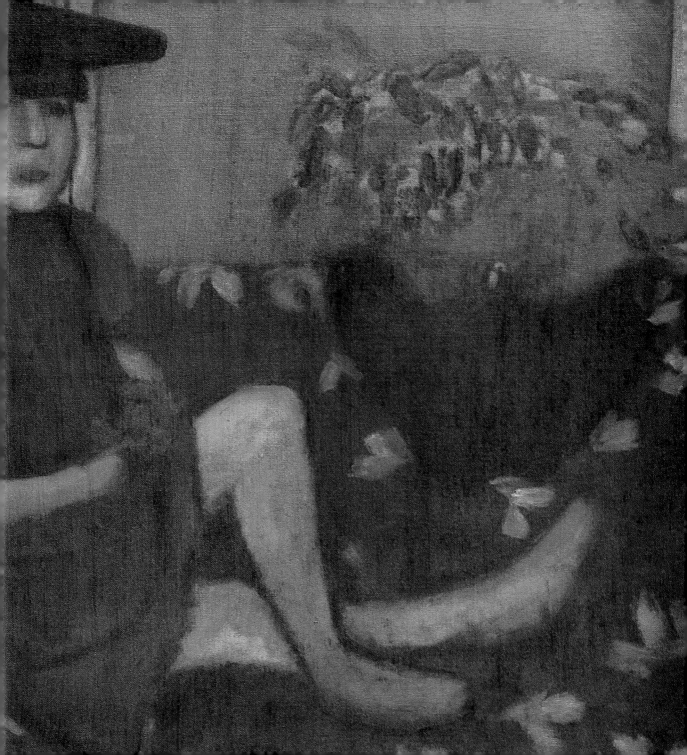

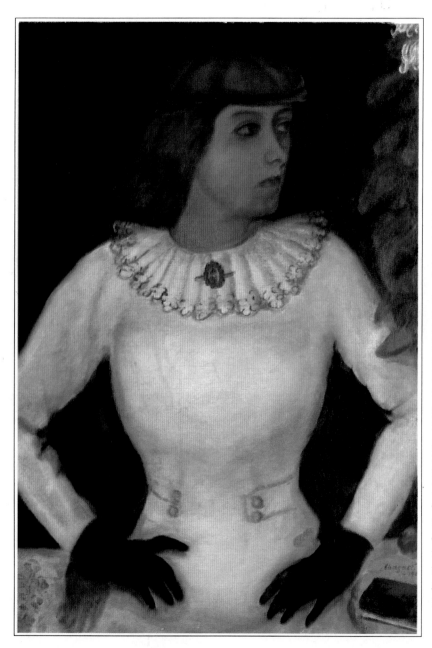

◁ **My Fiancée with Black Gloves** 1909

Oil on canvas

CHAGALL WAS STILL an art student at St Petersburg when, in October 1909, he paid a visit to his home town, Vitebsk. At the house of a girlfriend he met Bella Rosenfeld, and the two young people almost instantly fell in love. Whereas Marc had been born into poverty, Bella came from a wealthy Jewish family in Vitebsk and was an emancipated girl who had studied in Moscow and travelled abroad. Much of this is visible here in the determined set of Bella's head, her arms-akimbo posture, and the impression of severity given by her little hat, tight-fitting white dress, and black gloves. The portrait may reflect Chagall's timid attitude to women at that time, for in 1910 he painted his 20-year-old sister Aniuta in a similarly self-possessed pose. In the event, Bella proved willing to wait for Chagall until they were able to marry in 1915, and their romance lasted all their lives.

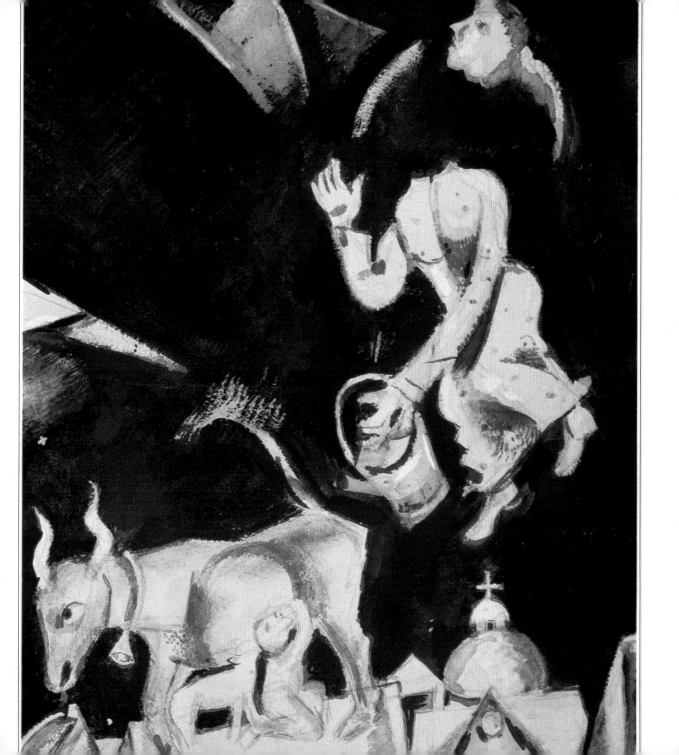

To Russia, Donkeys and Others 1911

Gouache

◁ *Previous page 11*

THIS IS A GOUACHE (painting in opaque watercolours), done as a preparatory study for a slightly later oil painting. The title was suggested to Chagall by his friend Blaise Cendrars, the French writer and traveller. It refers to an exhibition called 'The Donkey's Tail', mounted in Moscow and including paintings by Chagall; but in any case, the dedication of a work to his native land was significant at this point in his career. Having just moved into La Ruche, a kind of Parisian artists' colony, Chagall was exposed to a host of new ideas bubbling up in the wake of the Cubist revolution initiated by Picasso and Braque. The work incorporates some of these ideas, but also affirms his Russian roots and the visionary nature of his own inspiration. The peasant woman is an early example of Chagall's flying figures; here, head and body have mysteriously separated as she floats in the night sky above a Russian town.

▷ The Poet 1911

Oil on canvas

PAINTED ABOUT a year after Chagall's arrival in France, *The Poet,* or *Half Past Three* is a kind of modernist reworking of a relatively conventional portrait of one of Chagall's friends, the poet Mazin. Its style shows how rapidly Chagall absorbed the ideas of the Parisian avant-garde and then began to re-express them in his own fantastic idiom. The flat (non-three-dimensional) drawing, arbitrary colours and facetted forms all bear witness to the influence of Cubism and related movements; but Chagall's work is not primarily an analysis of forms in the Cubist manner but an evocation of artistic inspiration. The poet sits at a table, pen in hand, drinking coffee but with a bottle of something more potent to hand; however, inspiration seems to have arrived without its aid. The picture has an extraordinary sense of movement, traceable to the thrust of the bottle and red tabletop towards the poet's topsy-turvy head, which conveys the emotional upheaval involved in the creative act.

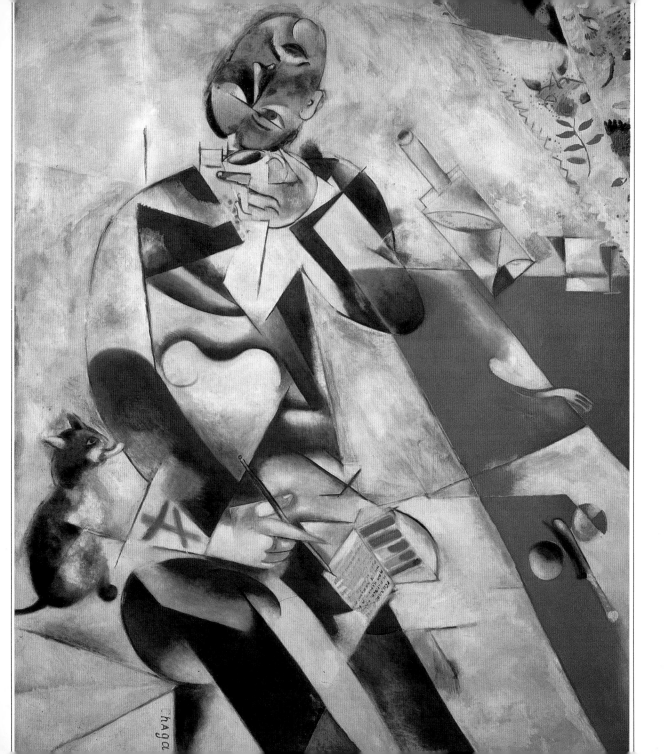

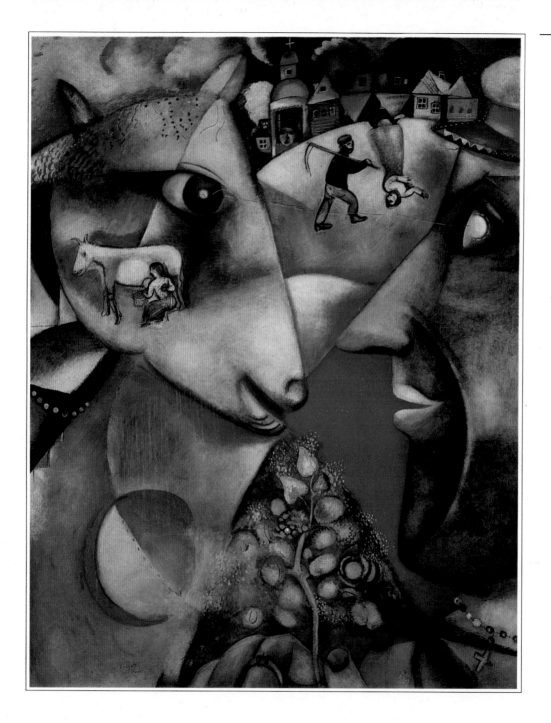

◁ **I and the Village** 1911-12

Oil on canvas

ONE OF THE BOLDEST and most successful essays in modernity and magic from Chagall's Paris years. The segmented circles and their colouring style derive from Chagall's friend Robert Delaunay, a French painter who made it the basis of a post-Cubist movement known as Orphism. As usual, Chagall takes over the elements of an avant-garde style, but employs them in an unprogrammatic spirit and combines them with apparently incongruous subject matter drawn from memories of his youth in Vitebsk. In this painting, a dream-like irrationality is as all-pervasive as anything produced a decade later in the name of Surrealism. Man and beast appear to engage in friendly conversation, although the man's face is green and the transparency of the beast's head enables us to see the milking scene within its contour. A church with a cross above a cupola indicates that we are in Vitebsk, where two houses and a woman are upside down and, equally mysteriously, a man is returning home with his scythe although it is after nightfall.

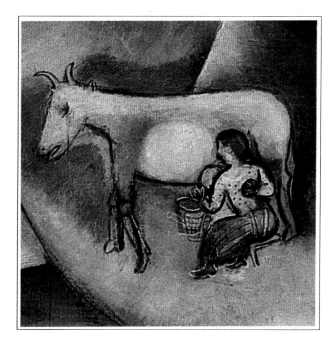

Detail

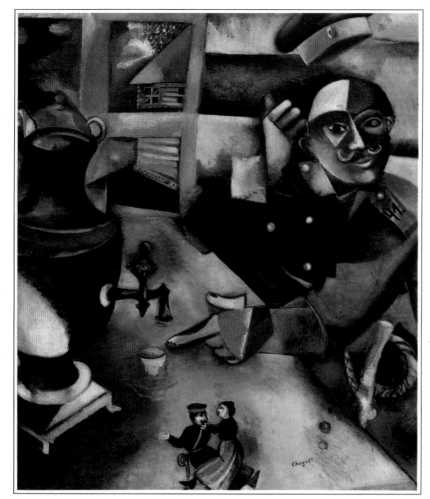

◁ **The Soldier Drinks** 1912

Oil on canvas

ANOTHER CANVAS, painted in Paris but redolent of Russia, in which Chagall took over avant-garde techniques (Cubist geometry and the arbitrary colours of the Fauve painters) but used them to enhance the bizarre, super-real quality of his fantasies and memories. According to Chagall himself, the picture draws on memories of the soldiers billeted in the family house during the Russo-Japanese War of 1905-6. This was unlikely to have been a pleasant experience for a Jewish household, but Chagall has made his soldier an apparently amiable monster, with one green and one blue eye, whose hat has mysteriously floated away from his head. He points to the cup and the outsize, steaming samovar while simultaneously gesturing with his right thumb, presumably at the lurid scene through the window. The little figures at the front probably represent the same soldier with one of the conquests he likes to boast about.

▷ **Adam and Eve** 1912

Oil on canvas

ALSO KNOWN AS *Temptation*, referring of course to the biblical episode in which first Eve, and then Adam, is tempted to eat the fruit of the Tree of Knowledge of Good and Evil. Interestingly, Chagall chooses the foundation-myth of Judaism as the subject of his most 'modern' pre-war work: at no other time did he come so close to the Cubist breaking down of reality into facetted geometric forms, pioneered from about 1909 by Picasso and Braque. Even so, this is not a fully-fledged Cubist work. The Cubists abolished space, making their subjects part of an overall surface design, but Chagall insists upon a sense of physical reality, using pale tones to create an illusion of three-dimension and putting in a patch of blue sky. Nor is his characteristic fantasy entirely absent, thanks to the unobtrusive presence of tiny, unicorn-like creatures, one of them with a bird resting on its horn, which seem to have invaded the picture from a different set of myths.

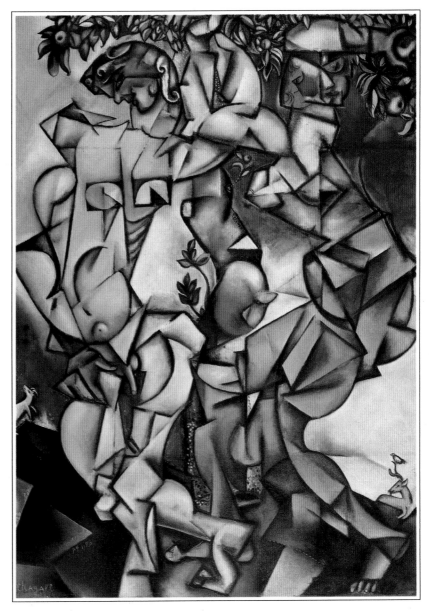

▷ **Golgotha** 1912

Oil on canvas

CHAGALL, a Jew, was deeply fascinated by the Crucifixion as an image of suffering and redemption, although his interpretations of the event are never orthodox. In the 1930s, for example, he emphasized Jesus' Jewishness and combined the figure on the cross with scenes of Nazi persecution (*The White Crucifixion*, page 52). Here, Jesus is shown as a child, in an unusual, almost triumphant posture. In the extraordinarily rich colour scheme of the picture, he is a luminous blue – the traditional colour of spirituality – and suspended between the red earth and the green heavens. As well as the group at the foot of the cross, a man waits in a boat on a strip of water, and another marches away with a ladder. It has been suggested that they represent Charon (in classical myth the ferryman who rowed the dead across to the underworld) and Judas; but despite many interpretations the exact meaning of the picture remains elusive. What is not in doubt is its intensity and power.

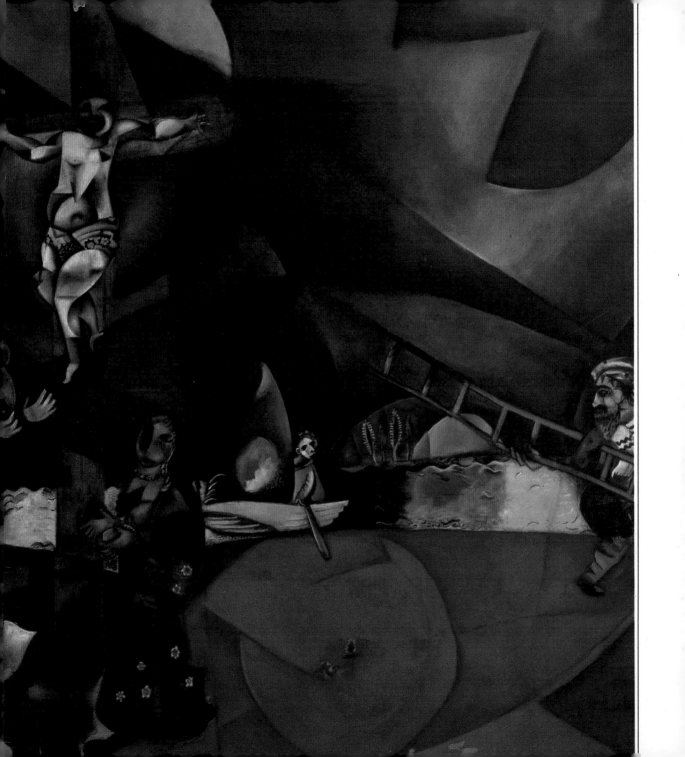

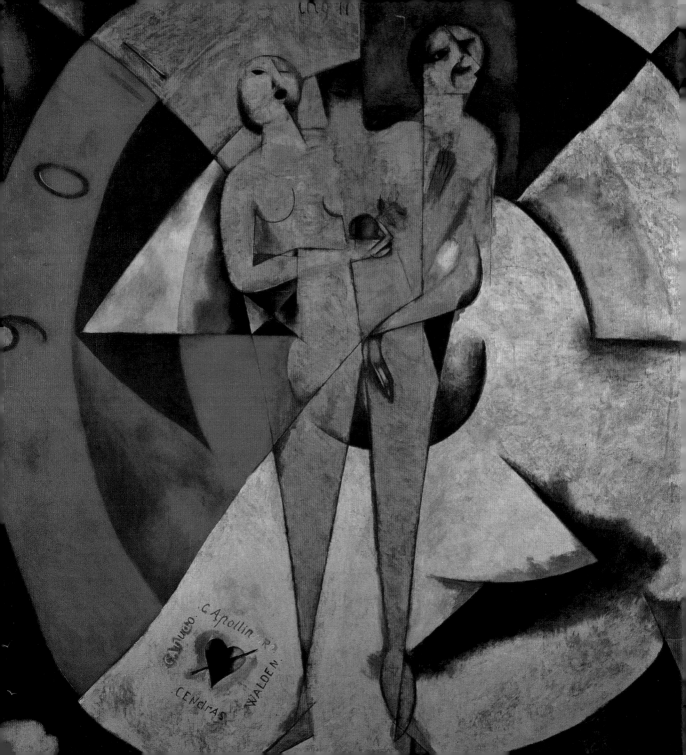

◁ **Homage to Apollinaire** 1911-13

Oil and powdered gold and silver on canvas

THIS IS A RATHER uncharacteristic work, combining geometry with much mystification, including elaborate puns on the names of the dedicatees. The title used nowadays is shorthand: as the names around the heart at the bottom of the picture make plain, the canvas is actually a homage to four friends who helped Chagall in various ways. The writer Guillaume Apollinaire, one of the great publicists of modern art, trumpeted Chagall's virtues and arranged exhibitions of his work; the dealer Herwarth Walden introduced it to Germany; Riciotto Canudo was an encouraging periodical editor; and Blaise Cendrars, French poet, novelist and travel writer, was a close friend who supplied the titles for many of Chagall's paintings. As in *I and the Village* (page 15), the segmented Orphic circle appears, this time resembling a clock face from which most of the numbers have dropped off. The human figures are Adam and Eve, joined together like Siamese twins. The date on the picture is 1911, but it is more likely to have been painted in 1913.

Paris through the Window 1913

Oil on canvas

▷ *Overleaf page 22*

IN THIS CHARMING, colourful work Chagall celebrates the city he had come to love as his 'second Vitebsk'. Many French artists, including contemporaries such as Matisse and Bonnard, painted town or country views seen through windows, a device that makes for pleasant contrasts of inside and out, shadows and light, cool and warm. But Chagall's vision transforms both realms into his own fantasy world. The interior is inhabited by a Janus-faced character next to the window and a human-headed cat sitting on the sill. Outside, the Eiffel Tower is the least strange object in a townscape where the train runs upside-down and a workman parachutes from a sky made up of coloured segments like those seen in *Homage to Apollinaire* (left) and other works of this period. Yet the sum of all these incongruities is an intensely romantic evocation of the city.

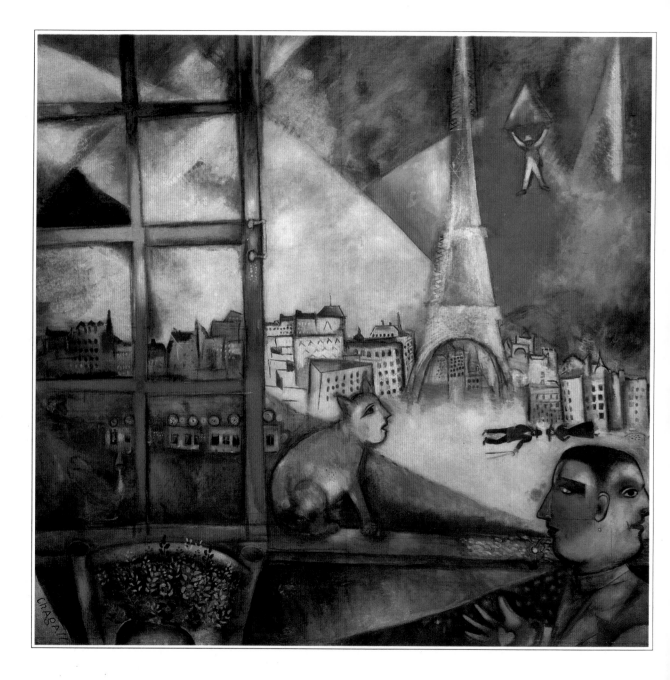

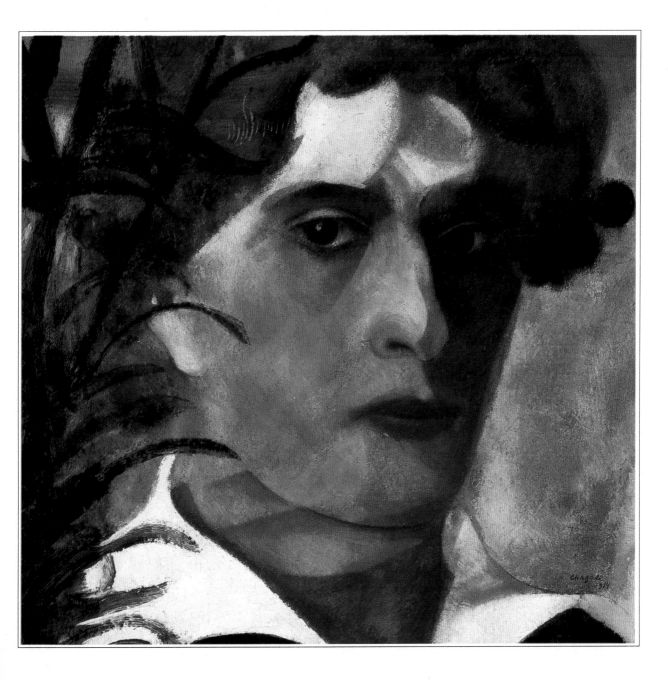

Self-portrait 1914

Oil on cardboard

◁ *Previous page 23*

IN 1914 CHAGALL was on the brink of international recognition. He travelled to Germany for his first large one-man show, held in June at the Der Sturm gallery in Berlin. Then he went on to Russia, intending to see his family and marry Bella Rosenfeld before returning to Paris. Instead, the outbreak of World War I in August 1914 prevented him from leaving Russia, though he can hardly have imagined that he would not see Paris again for nine years. Around 1914 he executed a series of self-portraits, of which this one is notable for its directness; for once, fantasy and caricature are absent. Although Chagall's curiously feminine features are very much in evidence, he shows himself in a wholly serious guise, perhaps still believing that 'the war will be over by Christmas' and that he will be able to resume his Parisian career. Like many of his subsequent wartime pictures, the *Self-portrait* was painted on cardboard because canvas was unavailable.

▷ **The Praying Jew** 1914

Oil on canvas

ALSO KNOWN AS *The Rabbi of Vitebsk*. This was painted very soon after Chagall's return to Russia in 1914, a temporary visit that turned into an eight-year stay as first the World War and later the Revolution made it impossible for Chagall to leave. Stranded in Vitebsk, he painted a series of portraits of elderly Jews. This is the most solemnly religious one, which Chagall evidently liked, since he painted several versions. He has described how he invited an old man into his parents' house, and paid him 20 kopeks to put on a prayer shawl and other ritual objects belonging to Chagall's father. Two styles are fused in the picture: the face is a completely naturalistic study of an individual whom it would be possible to identify in a crowd, whereas the treatment of the prayer shawl is stylized so that it brings it close to geometric abstraction. With its predominance of black and white lending it great dignity, the result is one of Chagall's masterpieces.

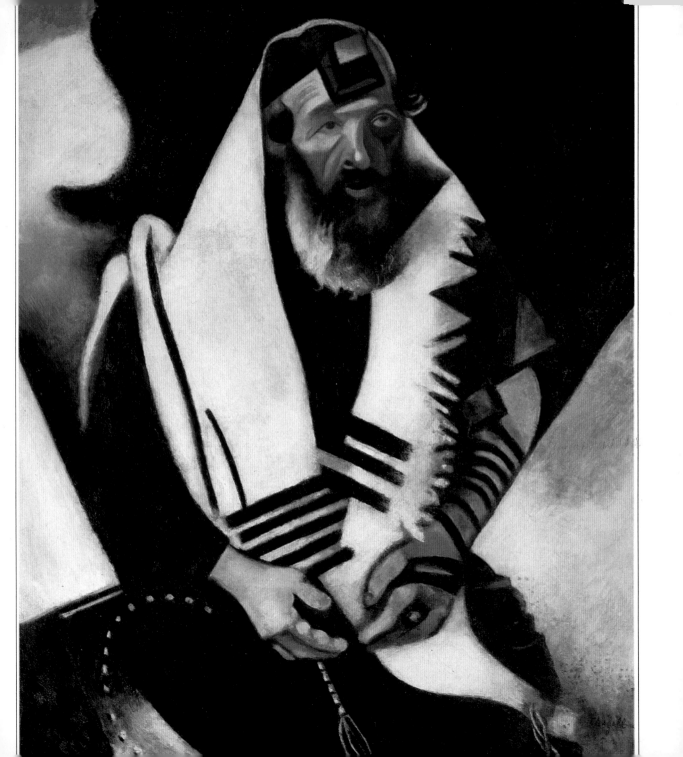

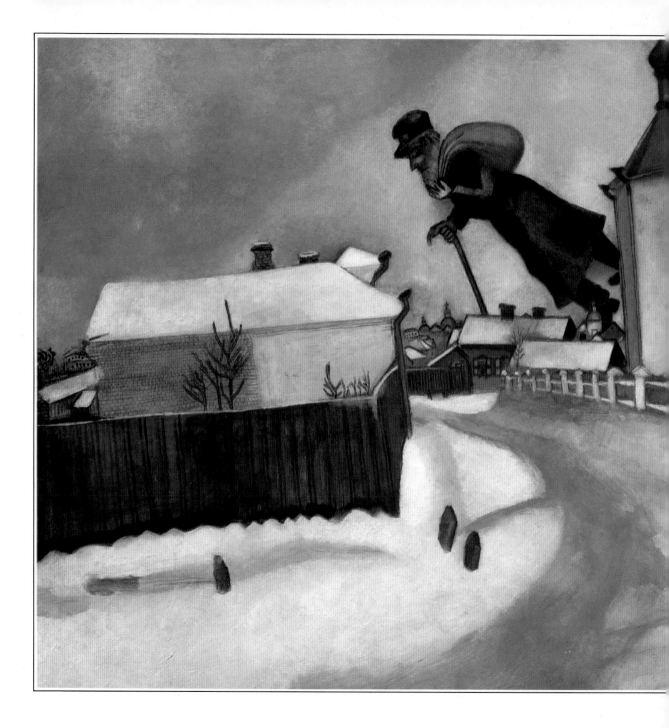

◁ **Over Vitebsk (detail)** 1914

Oil on cardboard

THIS WAS PAINTED shortly after Chagall's return to Vitebsk, at about the same time as *The Praying Jew* (page 24) and other overtly Jewish subjects suggested by his reappraisal of the old environment. Here the figure of a man is also Jewish, but this time he is a beggar carrying a bundle and stick. Such a tramp was often described in Yiddish as 'one who walks over the city', a fact that has sometimes been put forward to explain his ability to levitate. But this hardly accounts for Chagall's lifelong taste for flying figures, who are more often lovers than beggars. The wandering beggar certainly evokes the unhappy fate of the Jewish people in Russia, which must have struck Chagall all the more forcibly after he had experienced the liberated atmosphere of Western Europe. The setting for the painting is a suburb of Vitebsk, shown realistically, but tilted to convey the vertigo of flight – which the old beggar seems to be taking calmly enough.

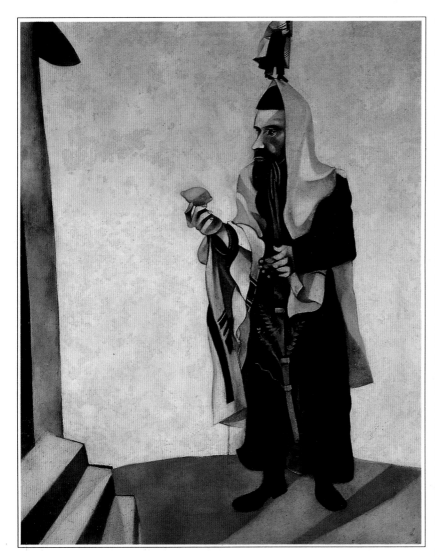

◁ **Feast Day** 1914

Oil on cardboard

ALSO KNOWN AS *Rabbi with a Lemon.* This pious individual, draped in his prayer shawl, is celebrating the Feast of Tabernacles, or Succoth, which commemorates the Hebrews crossing the desert under Moses's leadership. The items carried by the rabbi are those laid down by the Bible (Leviticus XXXIII), which states that 'On the first day you shall take the fruit of citrus trees, palm fronds and leafy branches, and willows from the riverside, and you shall rejoice before the Lord your God for seven days.' As usual, Chagall's vision is less conventional than it at first appears to be: there is no sign of an orthodox tabernacle canopied by boughs, and the bareness of the scene is reminiscent of early Italian Renaissance paintings of Christian subjects. These sometimes feature small, model-like objects such as a group of angels or even a church, completely out of scale with the rest of the scene; and this may have inspired the little figure, also bearded and shawled, so strangely placed upon the rabbi's head.

▷ **The Red Jew** 1915

Oil on cardboard

The Red Jew belongs to the same phase of Chagall's second Russian period as *The Praying Jew* (page 24); but this is a tougher, older character who gives the impression of having struggled and endured much during his lifetime. The model for this painting, and also for its more melancholy companion piece, *The Green Jew,* was in fact a preacher from Slutsk; the inkpot and pen on the rooftop behind him, and the Scriptural text in the background, evoke the long study, scholarly interpretations and heated debates that have played so large a part in Judaism. The shape of the painting, rounded at the top like a Christian icon or altarpiece, suggests that its subject is holy. The main figure, aged, tired and indomitable, carries great conviction, although neither his hands nor his feet are treated uniformly, as if to hint at some division within his personality. Heroic in scale, with the geometrically simplified forms of the houses tucked behind him, he dominates the composition.

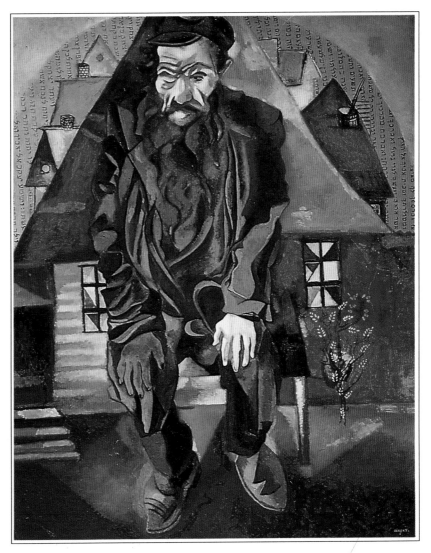

▷ **The Birthday** 1915

Oil on canvas

THIS PAINTING represents Chagall's poetic reworking of a fondly remembered incident which took place less than three weeks before his marriage to Bella Rosenfeld. Chagall was living on his own in a room he rented from a Vitebsk policeman. He had apparently never told Bella that 7 July was his birthday (he was always curiously evasive about dates), but she found out somehow and gathered a bouquet of flowers on the edge of the town. Then she put on her best dress and came to visit him, laden with blossoms. As so often when he wanted to convey intense emotion, Chagall made one of his lovers defy gravity. Here the painter himself is performing a strange flying turn to kiss his fiancée, who is still holding the bouquet. The background is essentially realistic; the view out of the window is a detail of the street in another 'flying' painting, *Over Vitebsk* (page 27).

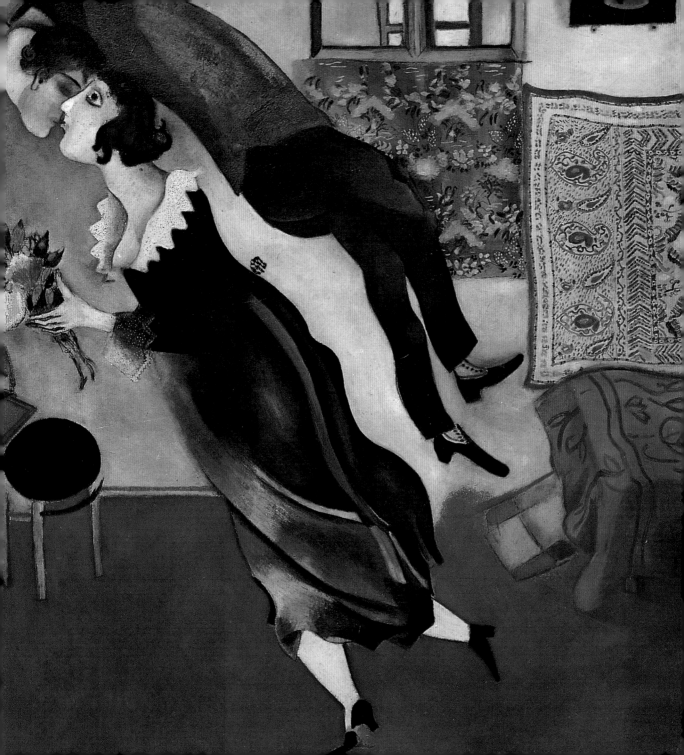

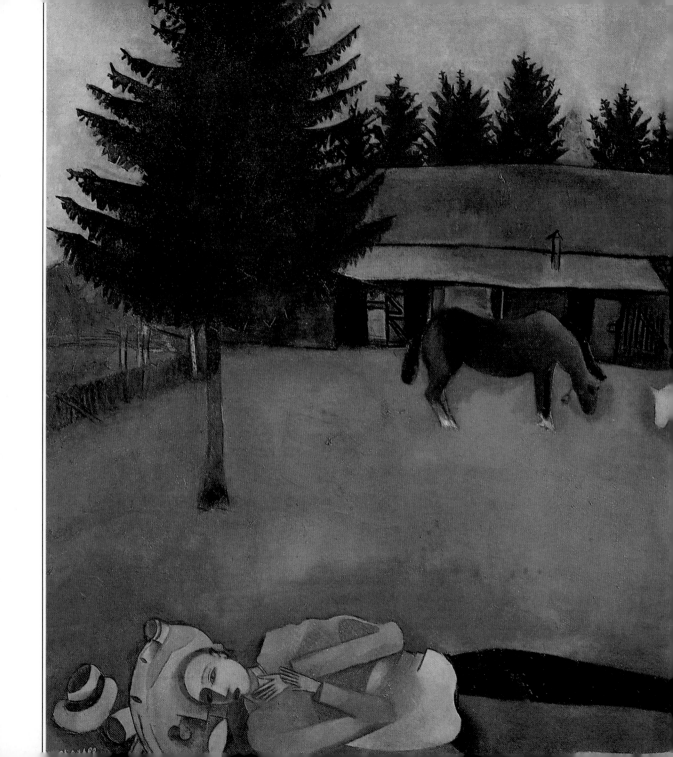

◁ **The Poet Reclining** 1915

Oil on cardboard

IN JULY 1915 Chagall married Bella Rosenfeld, who had been his fiancée since 1909 (see page 6). Their honeymoon in the countryside round Vitebsk fired his enthusiasm for rural themes, and this work was one of the earliest results. Its lush greenery and peacefully grazing animals suggest the joyful phase that his life had entered, but on closer inspection elements of unease can be discerned in the picture. The trees on each side and the poet stretched out all along the base serve to frame the scene, making it a little claustrophobic; and the poet, though certainly intended to represent Chagall himself, is an enigmatic, elongated figure with a Cubist-style head rather than a recognizable face. In any event, the idyll could not last in the middle of a war, and the Chagalls would soon be forced to move to St Petersburg, where he was able to avoid the carnage at the front by working in the Office of Economic Affairs.

Detail

▷ **The Synagogue** 1917

Oil on canvas

DOWN TO THE 20th century, the synagogue was the centre of every Jewish community in Eastern Europe and Tsarist Russia. Within its walls Jews worshipped, prayed and studied in a familiar, comfortable atmosphere that is almost tangible in Chagall's painting. But he also hints that this was a dusty, somnolent, backward-looking world. Chagall and many of his generation broke away from orthodoxy, drawn to secular ideas of 'emancipation' and doctrines such as Zionism and socialism. Chagall himself had a distinctly ambiguous attitude towards his Jewishness. Life in old Vitebsk remained a major theme of his art even when he was far away, living a cosmopolitan life in Paris – but still, that was the life he chose to live. Painter of crucifixions and ardent Zionist, maker of stained glass for cathedrals and devotee of the Old Testament prophets, self-proclaimed lover of Russia and citizen of France by choice – Chagall was patently one of those artists who are enriched rather than diminished by conflicting impulses and cultural tensions.

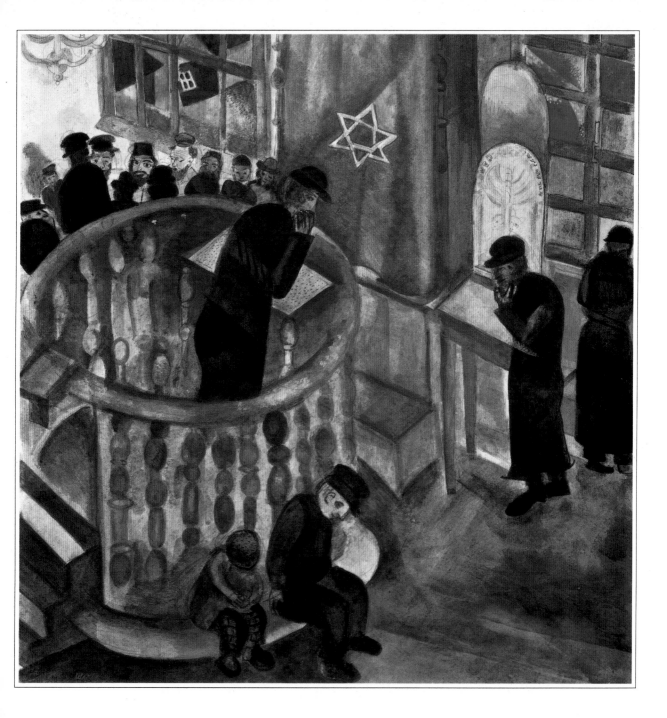

Detail

▷ **The Walk** 1917

Oil on canvas

ALSO KNOWN AS *The Promenade*. This is one of a series of canvases in which Chagall celebrated the joys of his marriage to Bella. The painting is full of delight – the couple are as pleased with themselves as acrobats who have pulled off a difficult trick – and their soaring spirits find a literal expression in Bella's floating figure. Marc holds a bird in one hand while he grasps Bella with the other. In a curious reversal, it is the human being, not the bird, that strains to take off into the blue, her weightlessness emphasized by the fact that one of her arms is already outside the picture. Bella's flight has evidently interrupted a picnic, indicated by the decanter and glass set out on a patterned red cloth – a brilliant touch, like the delicate blue leaves just above it. The non-naturalistic setting – the green town and landscape, and the sharp-edged forms – hark back to Chagall's Parisian paintings.

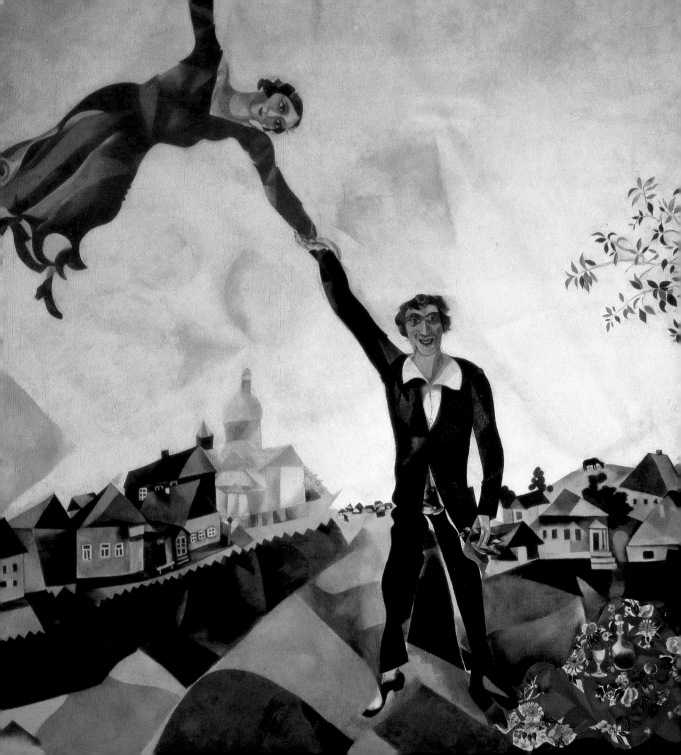

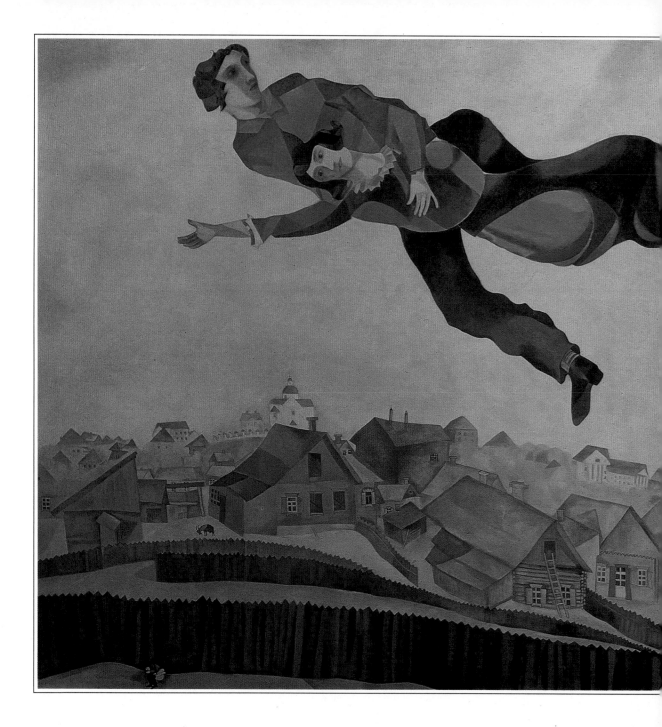

◁ **Above the Town** 1917-18

Oil on canvas

AFTER THE individual flights imagined by Chagall in *The Birthday* (page 30) and *The Walk* (page 36), he and Bella are now shown floating together over their native Vitebsk. Their mood seems more pensive here, but love still bathes everything in its own special ambience: the sweetness of Chagall's colours and his clear-cut, almost glossy forms give an air of beauty to the dreary, poverty-stricken suburbs where poor Jews lived. Though he was sometimes exasperated by it, Chagall loved Vitebsk and, when the 1917 October Revolution appeared to offer him an opportunity for power and influence, he preferred to quit Moscow and go home with his family. However, he was soon appointed director of the Vitebsk School of Fine Arts, and as such threw himself into an idealistic effort to bring art to the people, typical of the first phase of the Bolshevik regime. In later years Chagall – neither very practical nor very strong-minded – was amused by his own incongruous role as a Soviet functionary.

▷ **The Wedding** 1917-18

Oil on canvas

THIS LOVELY NIGHT-PIECE is perhaps the most touching of the long series of pictures, painted between 1915 and 1918, in which Chagall celebrated his love for his wife Bella; among other things, they serve to affirm the primacy of personal values in a world that was then, and for long afterwards, dominated by war and revolution. Here the couple are shown as bride and groom, brought together by an angel. The main feature of the background is a house, through the window of which we can see time-honoured symbols of domestic warmth and security, a lamp and a table laid for a meal. To the right of the house there is a fiddler (a traditional presence at an East European Jewish wedding), located with characteristic Chagallian fantasy in the fork of a tree. The little shape on Bella's cheek prefigures the birth of Chagall's daughter Ida in March 1916.

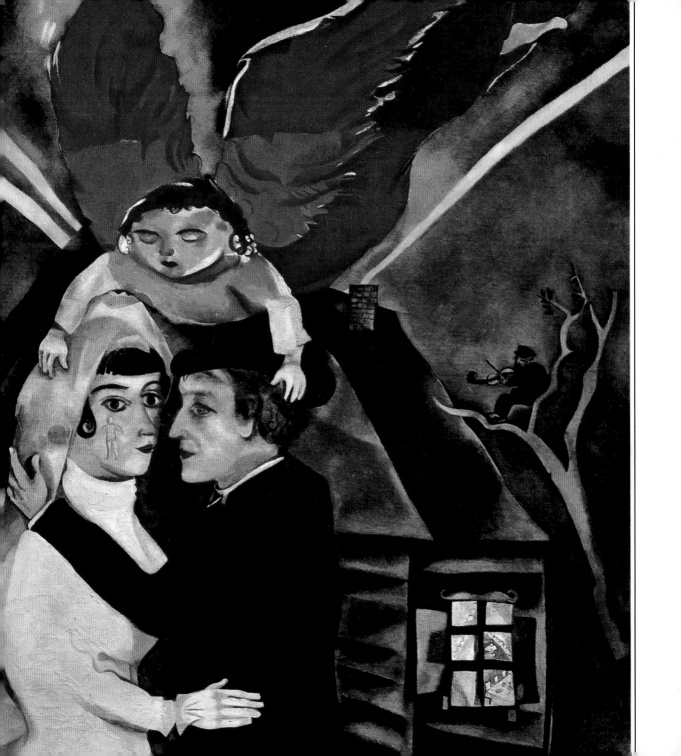

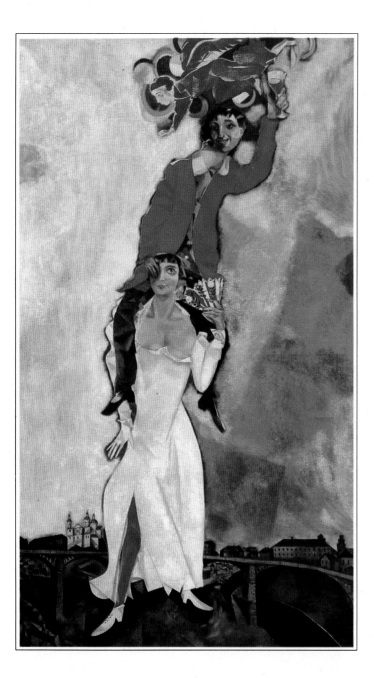

◁ **Double Portrait with a Wineglass** 1917-18

Oil on canvas

CHAGALL IS UNIQUE in the variety, exuberance and fantasy with which he celebrates married love. A curious aspect of this long series of works is how often they resemble literal picture-versions of well-known sayings or metaphors, every bit as apt in English as in Russian or Yiddish. 'Imaginative flights' nicely describes *Above the Town* (page 39) and many others, while here the couple are patently 'intoxicated with happiness'. Bella has turned acrobat and is rather unsteadily supporting Marc, who flourishes a glass of wine, apparently toasting the spectator; the impression of amiably alcoholic dislocation is intensified by Marc's misplaced head and Bella's covered eye (is she 'cockeyed'?), along with her fan and conspicuous *décolletage*. The angelic figure above the lovers, the brilliance of the colours and the division of the background into separate colour areas (each side of the human column) add to the delightful queerness of this canvas.

▷ The Green Violinist
1923-24

Oil on canvas

As COMMISSAR of Art in Vitebsk, Chagall managed to bring in leading artists such as Lissitsky and Malevich to teach at the town's academy. Ironically, this proved his undoing, since they soon involved him in disputes over aesthetics. Chagall allowed himself to be pushed aside and, perhaps with secret relief, left for Moscow in May 1920. He worked at the new Jewish National Theatre, the Kamerny, painting murals for the foyer and auditorium as well as designing the sets for the first production. One of the foyer murals was *Music,* represented by a fiddler, of which Chagall made this copy after finally leaving Russia in 1922. The fiddler traditionally led the proceedings at Jewish weddings in Eastern Europe and, as in other poor societies, his relatively inexpensive instrument was usually the one heard at other.festivals. Often pictured as lifted to the rooftops by musical emotion, fiddlers appear many times in Chagall's works.

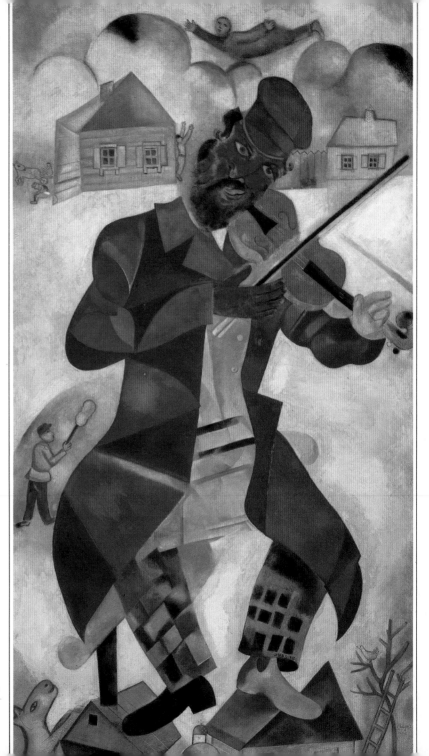

▷ **En Route** 1924-25

Oil on canvas

THE ALTERNATIVE TITLE of this painting, *The Wandering Jew,* confirms the affinity between its subject and the beggar in *Over Vitebsk* (page 27). The image of the Jew as a stateless being, forever en route but never reaching a final destination, might well have loomed large in Chagall's mind during this period, for it fitted his own recent experiences. Old Russia had disdained him as a Jew, and the new Soviet Russia was unenthusiastic about his art. Having chosen the life of an exile in Berlin, Chagall found his paintings dispersed and conditions chaotic. Finally, in September 1923 he returned to France. He suffered an initial trauma, finding all the works he had left in store at La Ruche had gone (perhaps only the unworldly Chagall could have imagined that a door secured by a bit of wire would remain unopened for nine years). Nevertheless his life in France during the 1920s was to be exceptionally happy and prosperous. *En Route* can be seen as a backward look – or as a prophesy of the renewed sufferings of the Nazi era.

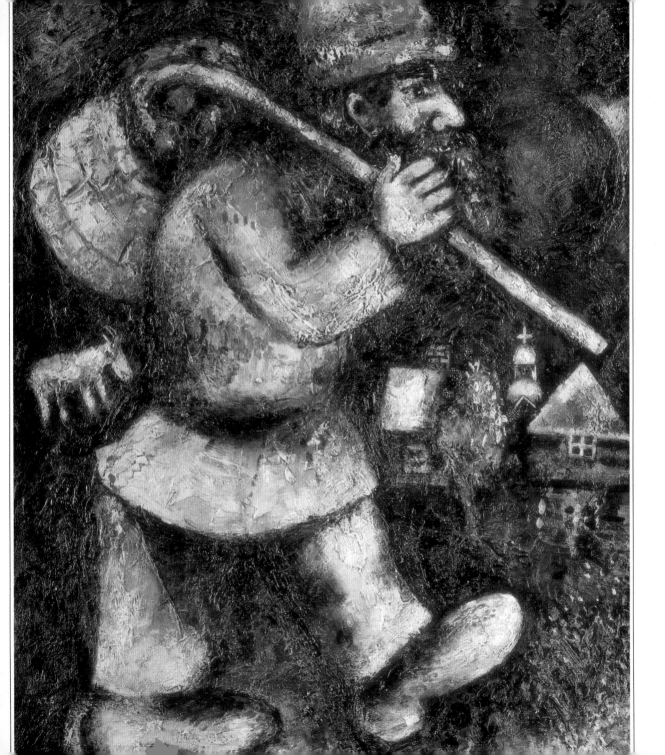

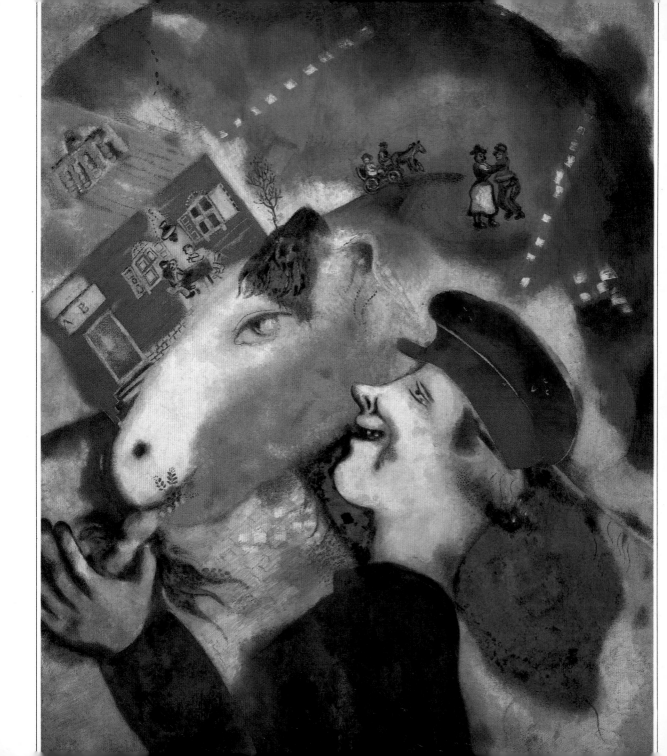

◁ **Peasant Life** 1925

Oil on canvas

Detail

IN THIS MERRY bucolic fantasy, the central figures are the peasant and his horse or donkey; the man smiles broadly while the beast contentedly munches the proferred snack. The background is very lively, with couples dancing and driving about, and an animated family group round a table in the tilted house. This painting has often been likened to *I and the Village* (page 15), but the comparison reveals the extent to which he had now thrown off Cubist-influenced geometry and developed his own style based on free association. In a sense, Chagall was producing surreal paintings long before the Surrealist movement got under way in 1924. But whereas Surrealist art was based on automatism (writing or painting in a trance-like state), Chagall's was always a controlled spontaneity ('consciously unconscious' was his own description): the simple but effectively arranged four-colour scheme of *Peasant Life* is a case in point.

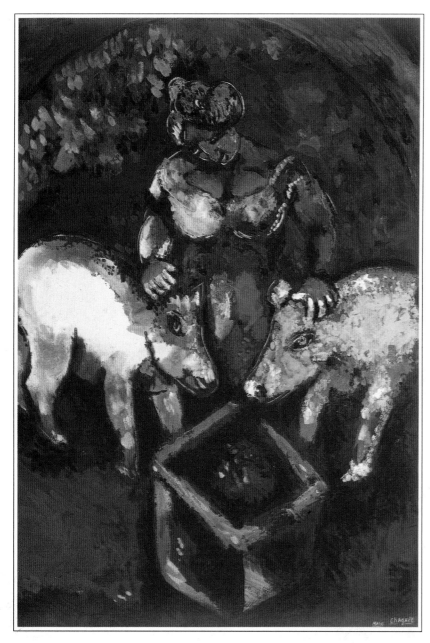

◁ **Woman with Pigs** 1926

Gouache

DURING THE 1920s the hard edges tended to disappear from Chagall's paintings, and he adopted a richer, more fluid style. The vivid colour and farmyard atmosphere of this work also owes much to Chagall's stay in the countryside at Mourillon, near Toulon, on the Mediterranean coast. Here he immersed himself in the atmosphere of traditional France, in preparation for a commission from the famous art dealer Ambroise Vollard to illustrate the *Fables* of La Fontaine. *Woman with Pigs* was one of a series of brilliant gouaches which he produced for this project, much criticized at the time by people who were shocked that one of France's great classics should be put into the hands of a Russian Jew rather than a native artist. Vollard responded by pointing out that La Fontaine's sources for his fables were actually Oriental, so that the choice of Chagall was singularly appropriate! Later, of course, Frenchmen would eagerly claim a world-famous Chagall.

▷ **The Acrobat** 1930

Oil on canvas

FROM THE LATE 1920s Chagall's
style became increasingly sweet
and 'painterly', with soft,
glowing colours and richly
textured surfaces. These were,
by his own account, Chagall's
happiest years: he was a
famous, well-off artist with a
loving family, now thoroughly
at home (and, it seemed,
secure) in the land of his
choice, France. Much of this
can be sensed in the painting.
Like many artists, Chagall was
fascinated by the circus and
the theatre, spheres where
illusion and virtuosity played
the same kind of role as they
do in the simulated realities of
a canvas. Chagall's circus
paintings encompass almost
his entire career, reflecting his
changes of mood and style. In
The Acrobat and related works,
the mood is so tender and
genial that even the fantasy
element is muted. Here it is
present only in the second
head – perhaps a trapeze
artist, but more probably one
of Chagall's lovers in full flight.

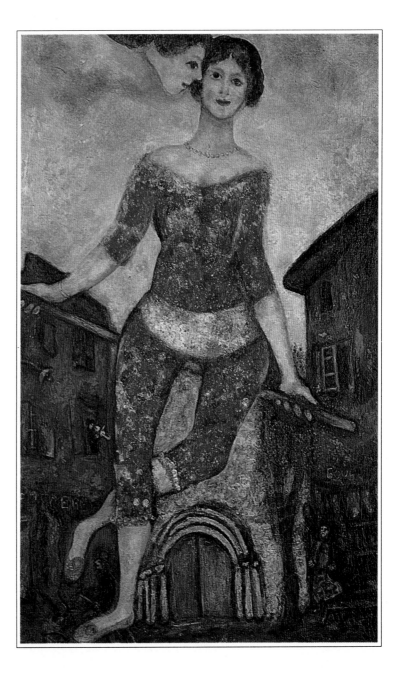

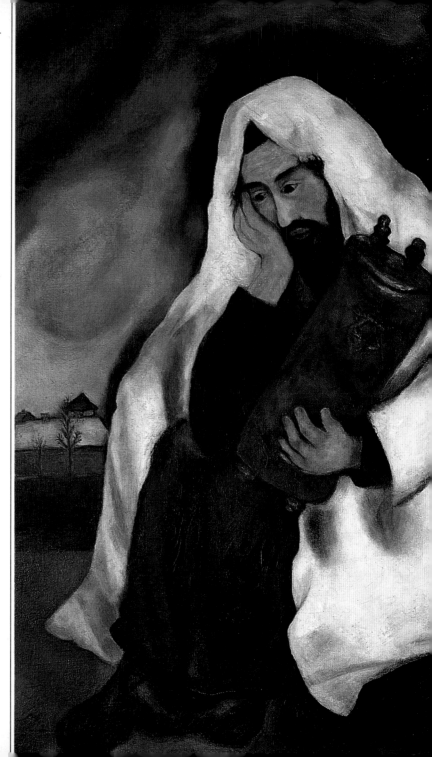

▷ **Solitude** 1933

Oil on canvas

THE GENTLE, sorrowful atmosphere inevitably recalls the Biblical text, 'By the waters of Babylon we sat down and wept: when we remembered thee, O Zion.' Thoughts of the Promised Land are certainly running through the head of the pious Jew, who sits covered with a shawl and clutching the Torah scroll. Chagall's 1931 trip to Palestine may have played a part in attracting him to the subject, but it is equally likely that he was responding to the increasingly threatening atmosphere of European politics – including the fact that, on 30 January 1933 Adolf Hitler had become chancellor of Germany. As yet there is hope, and the melancholy exile is still part of a magical world, sitting in the company of a white heifer with golden horns and a violin which is so positioned that, for all we know, the beast may be playing a Hebrew lament. Meanwhile, unnoticed, an angel flies away above the Russian town.

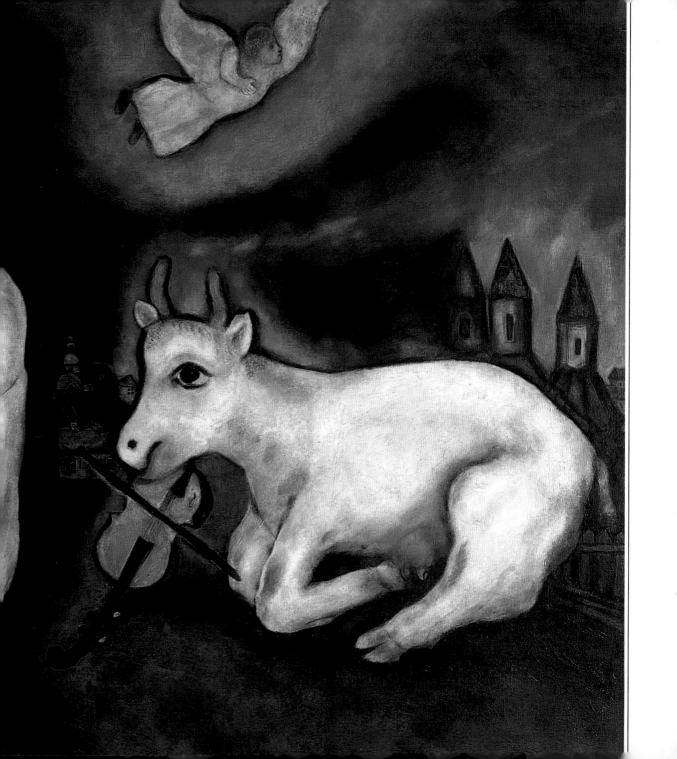

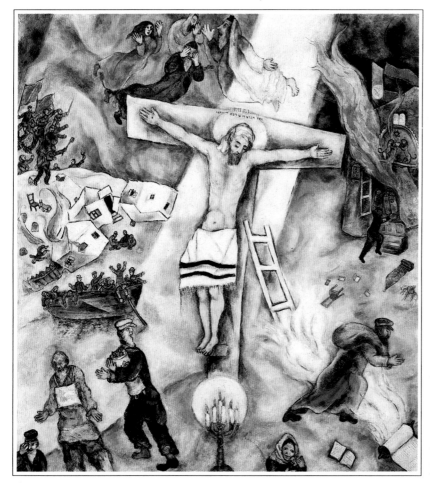

◁ **White Crucifixion** 1938

Oil on canvas

ORDINARILY THE LEAST political of artists, Chagall felt compelled in the late 1930s to respond to the world-shaking events of his time. In *The Revolution* (1937) he attempted to come to terms with his experience of the Russian Revolution and the Soviet state. *White Crucifixion* is an equally ambitious work, prompted by the modern face of a centuries-old phenomenon, the persecution of the Jews. Scenes of terror and flight wheel in a great circle: houses go up in flames, a Nazi stormtrooper desecrates the scrolls of the Law in a burning synagogue, while to the left a group waving red flags enter – whether as rescuers or ravagers is not clear. Amid the chaos stands a central column formed by a beam of light illuminating Jesus on the cross. As in earlier works such as *Golgotha* (page 18), Chagall emphasizes the Jewishness of Jesus. Wrapped in a striped prayer shawl and with a menorah (seven-branched candelabrum) at his feet, he embodies a world of suffering.

▷ **Time is a River
without Banks** 1939

Oil on canvas

THIS CANVAS received its poetic, if somewhat arcane, title after Chagall had finished painting it, so the relevance of the words to the picture can be questioned. The significance of the clock is clear enough in view of the way that Chagall has linked it with images of flight and a river ('Time, like an ever-rolling stream . . .'), although the apparently incongruous presence of the fish makes it easy to miss these more traditional elements. The mood of the picture is surprising, since even the predominance of blues does not generate the melancholy ambience normally associated with ideas of time and transience. One reason for this is the curious dynamism of the fish, which seems to be flying at speed while it simultaneously plays the violin. The river flows through an unidentified town, passing the oblivious lovers who add a note of tenderness to so many of Chagall's works.

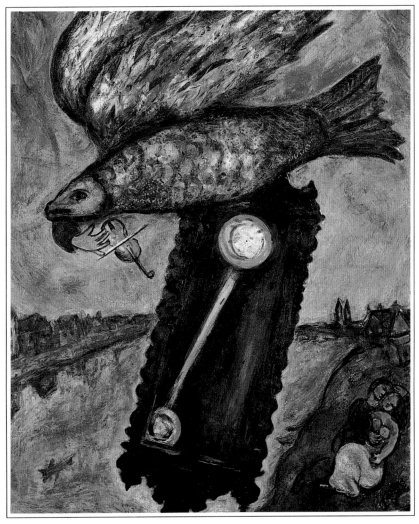

▷ **The Painter Crucified** 1941-42

Gouache

CRUCIFIXION was a form of execution used by the Romans all over their empire, but to most westerners it has become synonymous with the fate of Jesus. So there may seem something tasteless about Chagall's self-identification with 'the Crucified One', although such artistic licence is not entirely unprecedented (a great 16th-century German painter, Albrecht Dürer, also portrayed himself as a Christ figure). Chagall's unorthodox use of crucifixion themes had already appeared in *Golgotha* (page 18) and *The White Crucifixion* (page 52). In this example the palette and brushes leave no room for doubt about the identity of the crucified man, whose pinned left hand points to a more traditional image of Christ being taken down from the Cross. The clouds with hands, the upside-down buildings and the strange woman-beast create a sense of dislocation that is almost certainly connected with the date – the first winter following the German invasion of the USSR, when Chagall's native land was under Nazi occupation and the outcome of the World War hung in the balance.

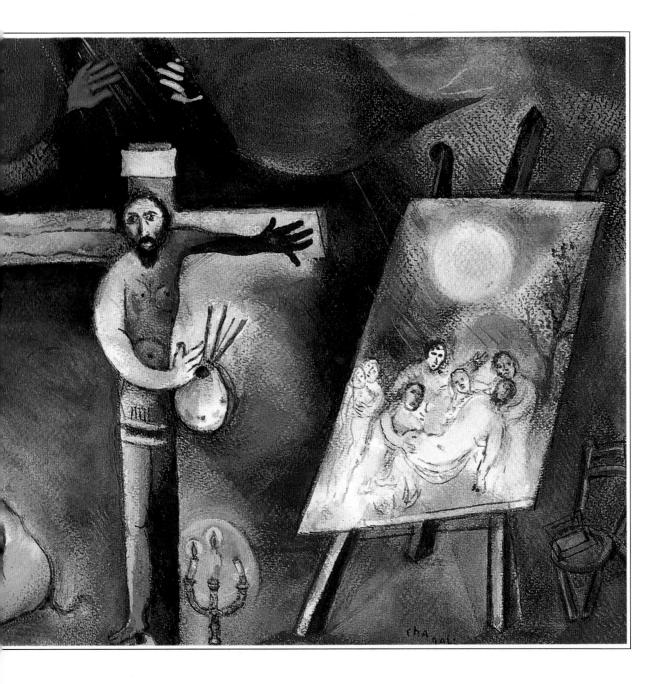

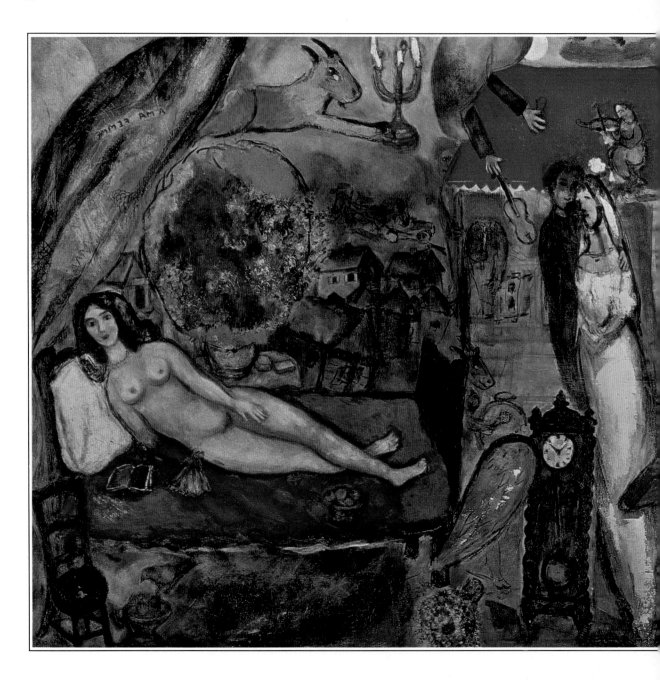

◁ **To My Wife** 1933/44

Oil on canvas

IN 1933, while he and Bella were living in Paris, Chagall completed a first version of this painting. Then it was reworked in the very different circumstances of his American exile during World War II; and Bella's sudden and unexpected death on 2 September 1944 gave it the quality of a memorial, summing up 29 years of married life. The reclining nude recalls the fact that – with great daring for those days – she had posed for him before their marriage. Bride and groom, the houses of Vitebsk, violins, angel, rooster, fish and goat – the Chagall repertory of images is well represented, even including the clock which harks back to *Time is a River without Banks* (page 53) and forward to *Clock with a Blue Wing* (page 63). Featuring many charming details, some just sketched in with a few strokes of the brush, this is one of Chagall's most delightful and saddest works.

▷ The Falling Angel
1923/33/47

Oil on canvas

BRILLIANT IN COLOUR but
sombre in its emotional tone,
this large, powerful canvas was
brought to fruition after a
gestation lasting almost 25
years. It was begun in 1923
with only two figures, the
angel and the bearded Jew
carrying a Torah scroll; by the
time it was finished, it
represented a summary of
Chagall's experience of war
and revolution, persecution,
flight and exile. The scarlet
angel – presumably Lucifer
himself – has a look of terror
on his face as he falls
explosively into Chagall's
world, flinging a young man
into the air. In the foreground
stands Vitebsk, and other
familiar images – the man with
a sack, the animal violinist and
the clock – evoke a world
whose destruction had been
completed during the war.
Everything is grouped round a
sun or star, except a mother
and child and a crucified man,
who inhabit a more tranquil
area. Chagall completed the
painting at High Falls in New
York State, shortly before he
returned to France for good.

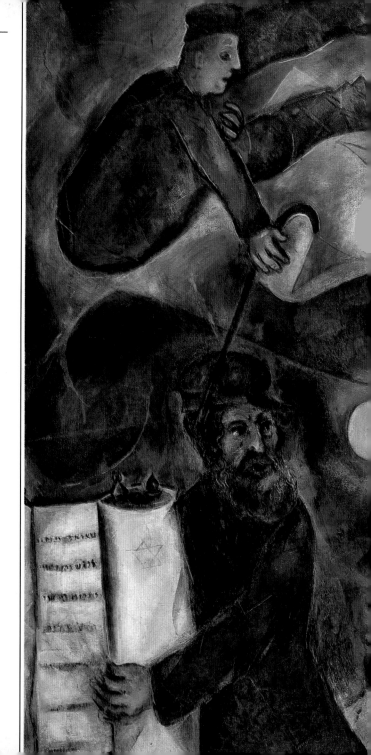

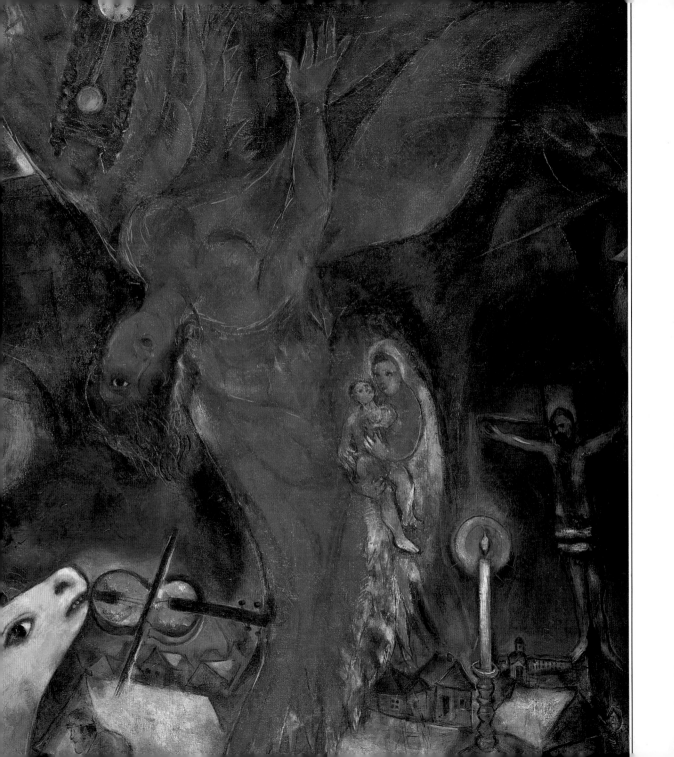

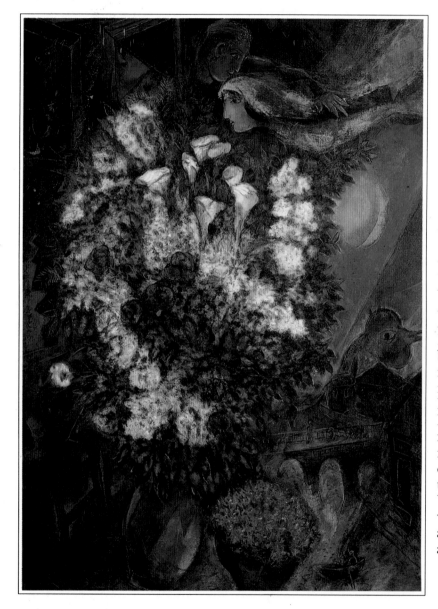

◁ Bouquet with Flying Lovers
c 1934/47

Oil on canvas

IN 1945 THE END of World War II and a new relationship (with Virginia Haggard) made Chagall a happier man. However, figures reminiscent of his dead wife Bella continued to appear in paintings of lovers such as this one. Like *To My Wife* (page 57), this is a repainting of a work done years before. Instead of the scene in the earlier version, showing lovers beside a window through which an angelic figure flies, the couple have been transformed into bride and groom. The Bella-figure, entering on a ray of moonlight, is herself the heaven-sent angel; her husband eagerly reaches out for her, but may find this night-visitant no more than a dream or memory. Beneath them is the old town of Vitebsk, with a large rooster who is perhaps about to announce the coming of dawn and dissolve the dream.

▷ **Still Life of Flowers** 1949

Gouache

DESPITE ITS TITLE this is not a
still life: they may on occasion
include human skulls or the
bodies of dead animals, the
still life by definition excludes
any living presence. It is
perhaps not surprising that
Chagall, so immersed in the
human and animal worlds,
seldom attempted this genre.
But in this and many other
paintings he pioneered what
was in effect a new, hybrid
genre, giving up most of the
canvas to a 'still life' – almost
always a colourful bouquet –
but introducing human lovers,
and animals round the
margins of the picture. The
humans are disproportionately
small. Sometimes, as in *Lovers
in the Lilacs* (1930), they are
stretched out side by side
within the bouquet;
sometimes, as if sheltered by a
flowing tree, they embrace
beneath its canopy; most often
they are shown as little more
than hands and shoulders,
buoyed up like swimmers by a
sea of blossoms. Here the
physical union of the lovers is
conveyed in a splendid
painterly shorthand.

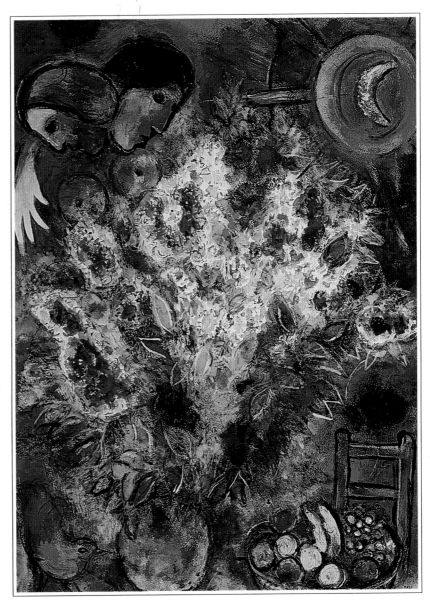

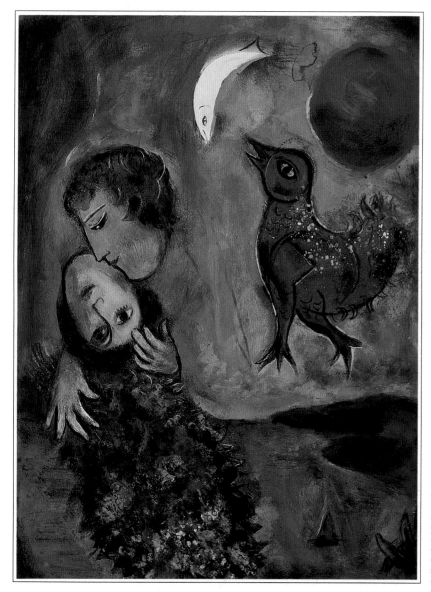

◁ **Blue Landscape** 1949

Gouache

AFTER A SEVEN-YEAR residence in the United States, Chagall returned to France for good in 1948. He lived in the countryside outside Paris for a time, but in 1949 he moved south, first to Saint Jean Cap Ferrat and then to Vence, just outside Nice. The colours of the Mediterranean, and especially its intense blues, were reflected in the even greater vividness of his palette. Often, as here, a single colour saturated the entire picture, ignoring the outlines of figures and objects; or the surface was demarcated into several large areas, each dominated by a different colour, as on the Paris Opéra ceiling (page 68). In *Blue Landscape* Chagall once more brings together lovers and flowers, a conjunction that had fascinated him since at least the 1920s, and one upon which he played endless inventive variations. This time, for once, it is the woman's head that is upside-down, perhaps indicating that love has turned her world topsy-turvy. The fish-moon is an *outré* image, even for Chagall!

▷ **Clock with a Blue Wing**
1949

Oil on canvas

ITSELF AN INSTANTLY accessible
image of time and memory,
the clock in this picture is said
to have been based on one in
the Chagall household in
Vitebsk where the painter
spent his boyhood. A flying
clock had already featured in
Time is a River without Banks
(page 53), where, mysteriously,
it had no hands or facial
markings. Later, in *To My Wife*
(page 57), the winged clock
appeared, very much as it is
here, among a group of
images connected with the
painter's dead wife, Bella. As
so often in Chagall's art, a
seemingly arbitrary image
proves to be a literal
counterpart to a saying – in
this case, that 'time flies'. The
scene is brightened by the
presence of the cockerel and
the bouquet, images associated
with Chagall's years in France;
but the setting is undoubtedly
snowbound old Vitebsk, with
the familiar, burdened figure
of a Russian Jew in the
foreground to put matters
beyond doubt.

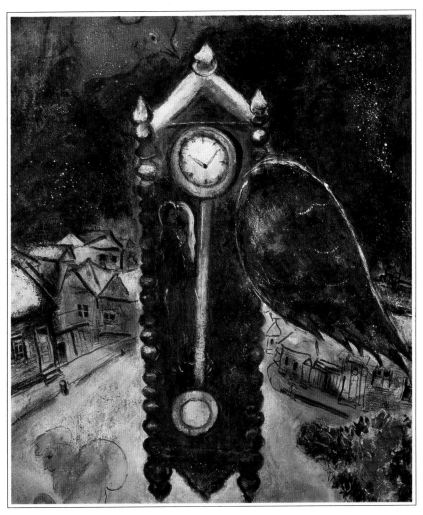

▷ **Bridges over the Seine** 1954

Oil on canvas

MUCH OF CHAGALL'S best work was inspired by memory, which bathed the once-familiar scenes of his life in a poetic ambience. Characteristically, having settled in the South of France, he painted a series of Parisian views in the early 1950s which show the city in its most romantic light; celebrated examples include *The Quai de Bercy* (1953) and *The Champ de Mars* (page 66). Here, the river Seine flows diagonally across the canvas, its shadowy bridges giving it the appearance of a ladder or railway track. A number of the city's famous monuments can just be seen, but the dominant, colourful elements in the picture are human beings: a red-robed mother suckling her child, precariously perched on an upside-down rooster; a horned and cloven-hoofed green donkey; and two lovers, floating in their own tender blue world.

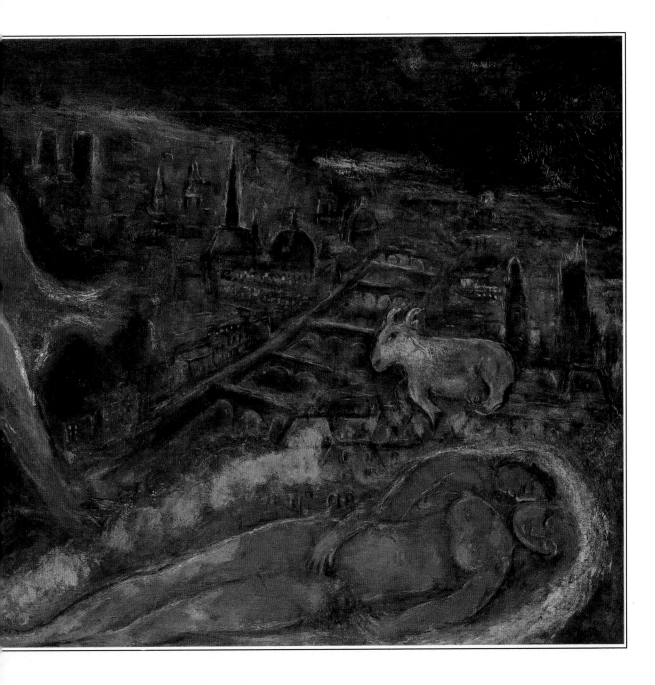

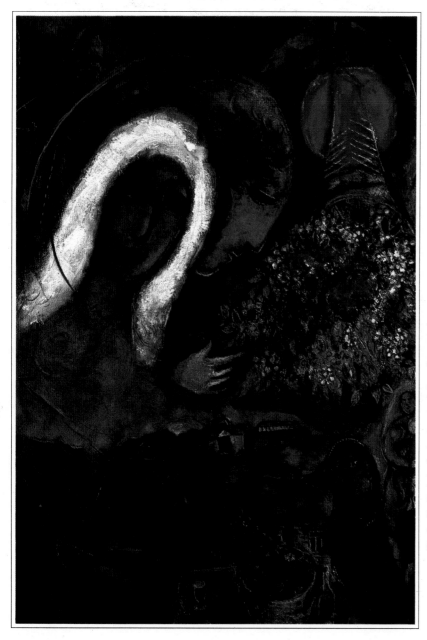

◁ **The Champ de Mars**
1954-55

Oil on canvas

THIS IS A WORK of pure poetry in which Chagall draws together many of the themes that had preoccupied him for so long. The scene is saturated in a friendly night-blue, with the flowers providing a patch of varied colours, naturalistically painted by the hand of a master. As always, flowers are associated with lovers; the woman's long white tresses vaguely suggest a halo. Behind and above the lovers are Parisian landmarks, notably the Sacré-Coeur in Montmartre and the Eiffel Tower. With characteristic obliquity, Chagall shows us the Tower but not the Champ de Mars, the large open area in which it stands and from which this canvas takes its title. The lower half of the picture looks further back in time, showing the huddled buildings of old Vitebsk, a mother and child, a table, and a typically strong and alert-looking bird.

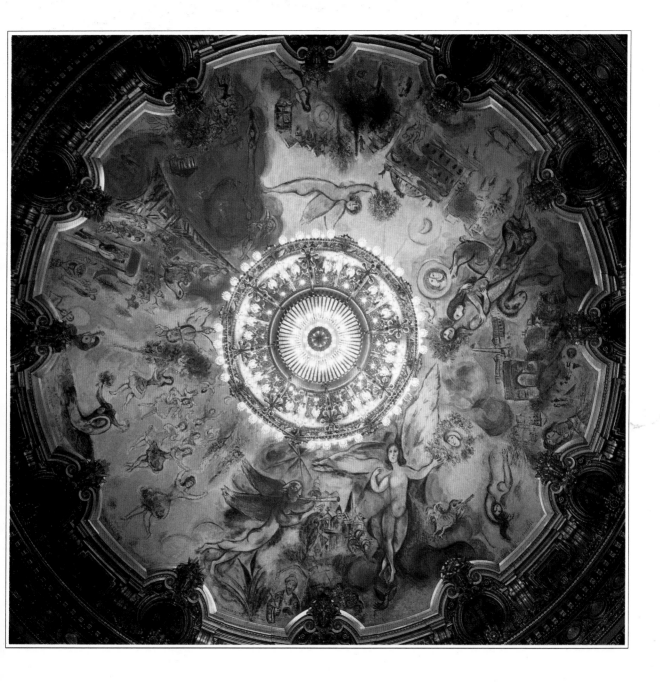

Ceiling of the Paris Opéra
1964

◁ *Previous page 67*

FROM THE 1950s Chagall was
occupied with a series of great
public commissions, including
stained glass, tapestries and
mosaics for buildings in
Europe, the USA, Israel and
Japan. Although he had
become a naturalized French
citizen in 1937, it seems
unlikely that he would have
been asked to work on the
Paris Opéra had not the
Minister of Culture been
André Malraux, a leading
20th-century writer and a
passionate and knowledgeable
art lover. Commissioned to
paint the roundel on the
ceiling of the auditorium, the
80-year-old Chagall made an
apparently effortless transition
from the relatively small scale
of the canvas to an enormous
mural; moreover his ethereal,
floating figures suited their
setting admirably. Like many
of his late paintings, the ceiling
is divided into a number of
areas, each saturated with a
particular colour. Here the five
areas serve to separate the
subjects; pairs of composers
shown with the main
characters from their works.

▷ War 1964-66

Oil on canvas

MUCH OF CHAGALL'S post-war
output was devoted to
pleasurable subjects, but from
time to time images of
destruction and flight surfaced
in his work, prompted by
memories of pogroms and
Nazi persecution, or perhaps
triggered by contemporary
events. Vitebsk burns and the
fleeing people are Jews, but
Chagall certainly meant the
painting to have a more
general application. It is one of
his bleakest statements. The
smoke-darkened sky, drab
refugees and soiled snow set
the mood; the only touch of
brightness is provided by the
destroying flames. By contrast
with *White Crucifixion* (page
52), the man on the cross is on
the edge of the canvas, half-
obscured by smoke and
surrounded by terrified and
despairing figures. Even the
horned beast seems more like
a sacrificial scapegoat than the
gentle heifer of *Solitude* (page
50), although the fact that he is
sheltering two lovers and their
child may represent a tiny
glimmer of hope.

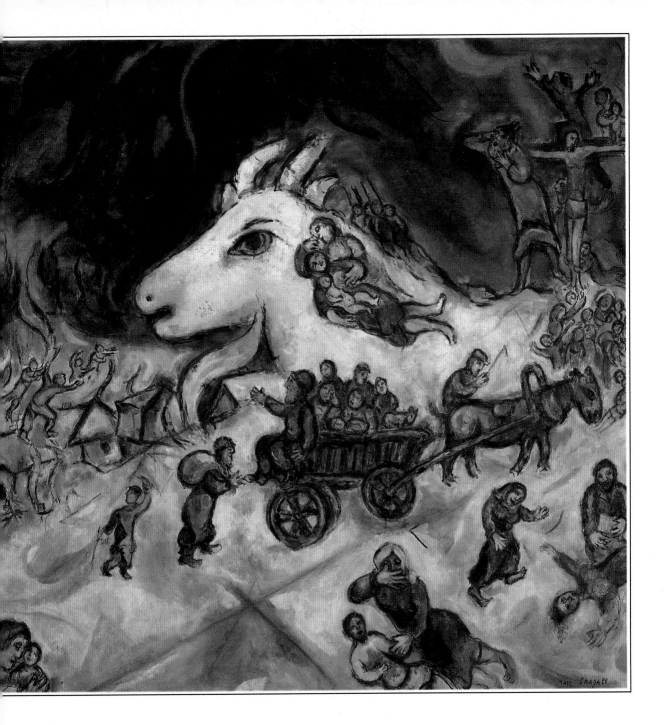

▷ **The Prophet Jeremiah** 1968

Oil on canvas

FROM 1930, when Chagall was commissioned to illustrate an edition of the Bible, he was intermittently inspired by its vivid characters and stories. Eventually, in the new state of Israel, he completed major projects in stained glass and mosaic that were also devoted to Biblical subjects. *The Prophet Jeremiah* is a work of Chagall's old age. Jeremiah was the most vehemently denunciatory of all the Old Testament prophets, warning the people that disaster would strike unless they mended their ways; he lived to see the Babylonians destroy Judah, and to flee into Egypt with his fellow countrymen. In Chagall's version the mood is sombre and sorrowful rather than angry. The yellow and white of the figures and the violet light pouring out of the composite sun-moon are set against a sombre background, creating an unworldly atmosphere appropriate to the only half-materialized angel. Tiny lovers and other figures can be seen on the margins of the scene, apparently insignificant by comparison with the communion between prophet and angel.

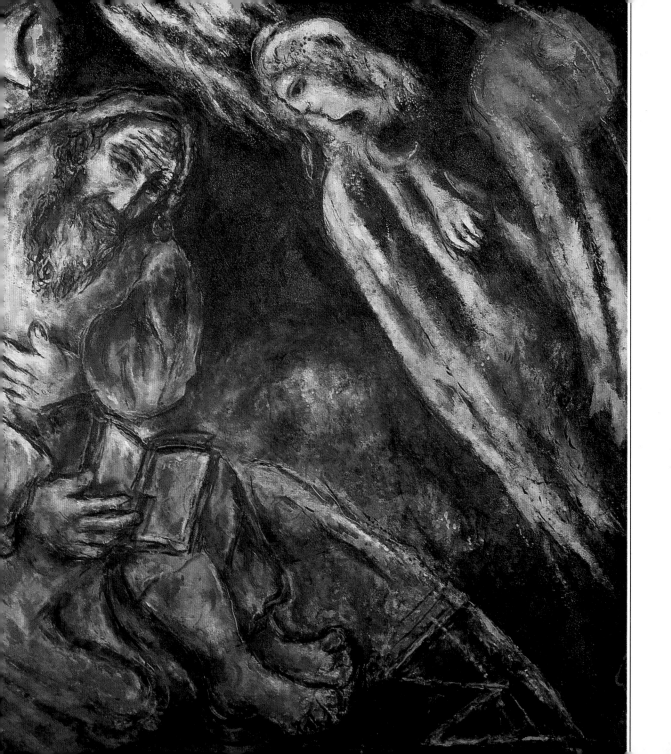

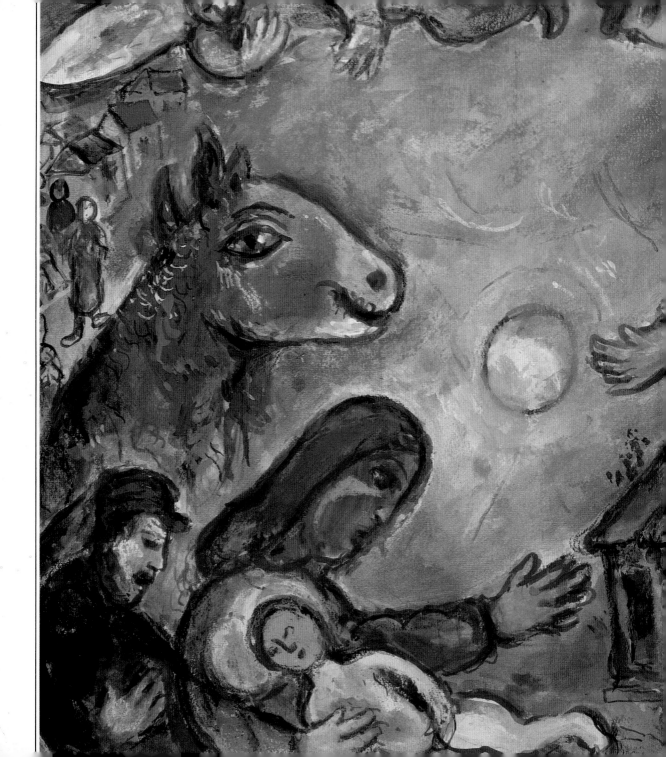

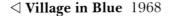

◁ **Village in Blue** 1968

Gouache

ALTHOUGH THEY no longer dominated his art, images of the Russia he had known still appeared from time to time in the works of Chagall's later years. In this painting, the flying figures continue to wear caps and beards and the streets are those of a long-vanished Vitebsk, before it was devastated by war and rebuilt as a modern city. The relatively large figures create an impression of crowding as they circle round the pale white sun or moon. The mood is oddly mixed, since the Chagall donkeys are their usual cheerful selves, whereas the woman carrying her baby is strangely agitated, as if in flight. The child's halo suggests that this may be a Bethlehem or Massacre of the Innocents scene, with Jewish angels and guardians and a Vitebsk setting. On the far right-hand side of the picture a faintly outlined figure has climbed out on to the rooftop, just as Chagall himself did in his boyhood.

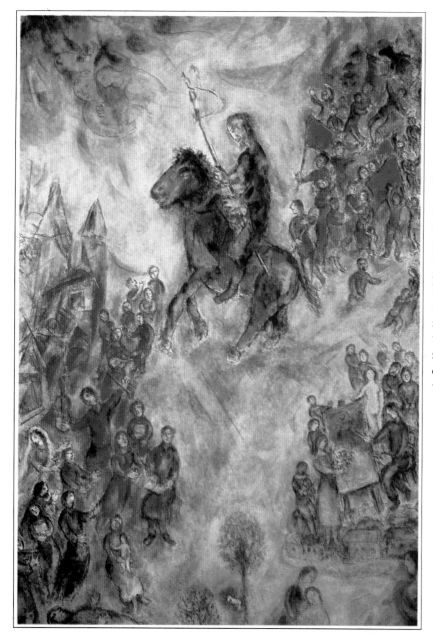

◁ **Don Quixote** 1975

Oil on canvas

DON QUIXOTE has become one of the great symbolic figures of western culture, and plays an appropriately dominant but ambiguous role in this picture. Here the misguided idealist seems to be leading a procession waving red flags as they bear down on a small crowd enjoying the ordinary pleasures of life. If this depicts the conflict between the ideal and the real, the group in the bottom right-hand corner must represent a third and separate realm – the poetic world of the artist himself, surrounded by the figures and objects on which he has worked his special magic.

The Fall of Icarus 1975

Oil on canvas

◁ *Previous page 75*

IN MOST OF HIS paintings, Chagall's imagery – his flying lovers and bouquets and circus performers and animals – was drawn from his private and personal mental stock, at best tangentially related to the public culture of the western world. Only in extreme old age did he tackle central themes such as *Don Quixote* (page 74) and, in the same year, *The Fall of Icarus.* As in *Don Quixote,* the event has become a crowd scene; despite the tragedy taking place above, the mood is festive and some of those present – including, incongruously, a nude woman – have turned up from other paintings by Chagall.

▷ Girl in the Waves 1978

Stained glass

MANY OF THE GREAT public commissions executed by Chagall in his old age were of a religious nature. This was not an accident, for his preoccupation with the subject was shown by the years he devoted to 'The Biblical Message', a great cycle of works now housed in their own museum at Cimiez, just outside Nice. Apparently oblivious of doctrinal differences, Chagall made stained glass for the Christian cathedrals of Metz and Reims as well as for a synagogue in Jerusalem. Other master-works in this medium can be found in the Kent countryside, at the Church of All Saints, Tudeley. The chancel is bathed in luscious blue light flooding through Chagall's windows, in which abstract forms are mixed with angels, birds and other creatures. The main east window commemorates Sarah d'Avigdor Goldsmid, a girl who died in an accident at sea. In Chagall's vision of the event she appears to be smiling among the waves, from which he also shows her risen and carried aloft on horseback.

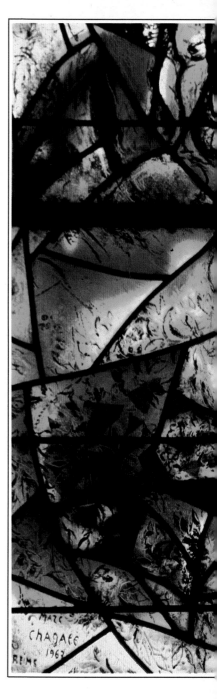

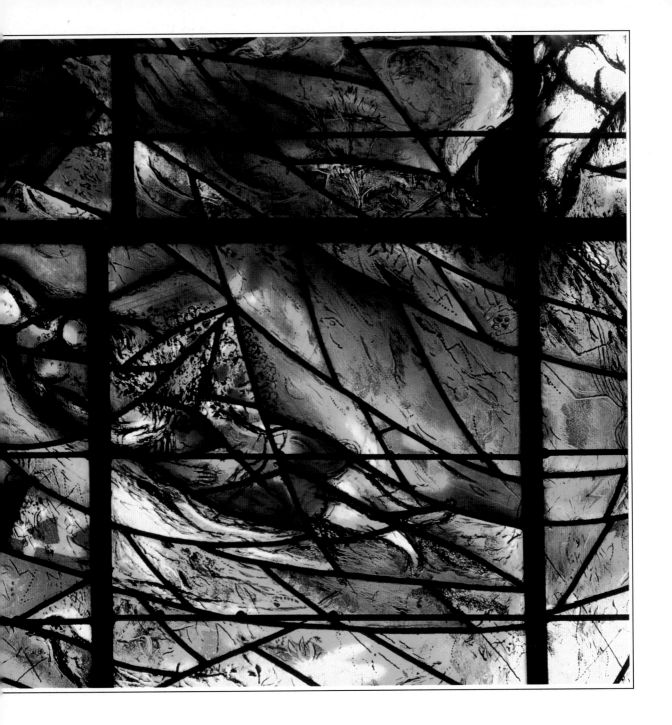

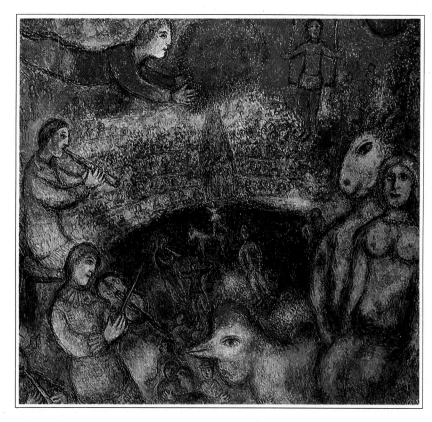

◁ **The Grand Parade** 1979-80

Oil on canvas

EVERY PERFORMANCE is supposed to end with a final curtain at which the players make their bows; so it seems appropriate to finish this book with *The Grand Parade*. The painting itself is a mélange of delicious colours, each saturating a particular area in Chagall's distinctive late manner. The cast of this particular performance includes an acrobat on a trapeze, a musician playing a clarinet-like instrument, a clown violinist, the amiable red-crested Chagall rooster, a naked woman, and a mythical creature of a type familiar from many other canvases. In the distance, the performers in the ring are also accepting the applause of the crowd. Swinging in at the top of the picture, another acrobat (probably representing Chagall himself) offers a large bouquet to all present. This was painted when Chagall was well over 90, but it was far from being his last work. By the time of his death in 1985 he had become arguably the longest-lived and most ceaselessly creative of all great artists.

ACKNOWLEDGEMENTS

The Publisher would like to thank the following for their kind permission to reproduce the paintings in this book:

Albright-Knox Art Gallery, Buffalo, New York, Room of Contemporary Art Fund, 1941 46, 47; /**Offentliche Kunstsammlung, Basel** 10; /**Private Collection** 58-59; /**The Bridgeman Art Library, London/Art Gallery of Ontario, Toronto** 26-27; /**Christie's, London** 8-9, 48, 54-55, 78; /**Collection of Tel Aviv Museum of Art** 50-51; /**Giraudon/Collection of Ida Mayer Chagall, Basle** 63; /**Hamburger Kunsthalle** 64-65; /**Heydt Museum, Wupportal** 61, 62; /**Kunstsammlung Nordrhein-Westfalen, Dusseldorf** 28; /**Kunsthaus Zurich** 68-69; /**Musée National d'Art Moderne, Centre Georges Pompidou, Paris** 42, 49, 56-57; /**Musée National d'Art Moderne, Paris** 75; /**Museo D'Arte Moderne Di Ca Pesaro, Venice** 25; /**Museum Folkwang, Essen, West Germany** 66; /**Museum of Fine Art, Budapest** 11, 72-73; /**Museum of Modern Art, New York** 14, 15, 18-19, 30-31, 53; /**Petit Palais, Geneva** 45; /**Philadelphia Museum of Art** 23; /**Solomon R. Guggenheim** 16, 22, 43; /**Private Collection** 34, 35, 70-71, 74; /**Sarah d'Avigdor-Goldsmid Memorial Window, All Saints, Tudeley, Kent** 76-77; /**State Russian Museum, St Petersburg** 1, 29, 36, 37; /**Tate Gallery, London** 32-33, 60; /**The Art Insitute of Chicago** 52; /**The Saint Louis Art Museum** 17; /**Tretyakof Gallery, Moscow** 38-39, 40-41.